ANCIENT EGYPTIAN DESIGNS AND MOTIFS

CD-ROM and Book

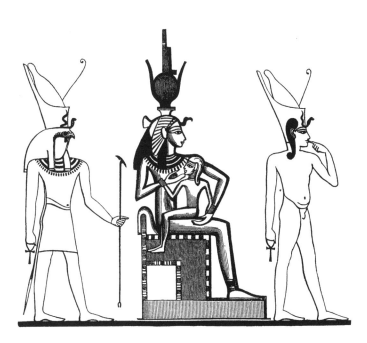

DOVER PUBLICATIONS, INC.
Mineola, New York

Copyright

Bibliographical Note

Ancient Egyptian Designs and Motifs CD-ROM and Book, first published in 2006, contains all of the images from *Egyptian Designs,* selected and arranged by Carol Belanger Grafton, originally published by Dover Publications, Inc., in 1993 and a new selection of color plates (pages 49–52) from *Décoration Égyptienne,* by Rene Grandjean, originally published by E. Henri, Paris, in 1923.

Dover Electronic Clip Art ®

International Standard Book Number: 0-486-99761-8

Manufactured in the United States of America
Dover Publications, Inc., 31 East 2nd Street, Mineola, N.Y. 11501

The CD-ROM in this book contains all of the images. There is no installation necessary. Just insert the CD into your computer and call the images into your favorite software (refer to the documentation with your software for further instructions).

The "Images" folder on the CD contains a number of different folders. Each black-and-white image has been scanned at 600 dpi and saved in six different formats—BMP, EPS, GIF, JPEG, PICT, and TIFF. The JPEG and GIF files—the most popular graphics file types used on the Web—are Internet-ready. The "Color Images" folder contains all of the color images scanned as 300-dpi TIFF files and Internet-ready JPEG files. All of the black-and-white TIFF images have been placed in one folder, as have all of black-and-white PICT, all of the color JPEG, etc. The images in each of the black-and-white folders are identical except for file format. All of the color folders are identical as well. Every image has a unique file name in the following format: xxx.xxx. The first 3 or 4 characters of the file name, before the period, correspond to the number printed with the image in the book. The last 3 characters of the file name, after the period, refer to the file format. So, 001.TIF would be the first file in the TIFF folder.

Also included on the CD-ROM is Dover Design Manager, a simple graphics editing program for Windows that will allow you to view, print, crop, and rotate the images.

For technical support, contact:
Telephone: 1 (617) 249-0245
Fax: 1 (617) 249-0245
Email: dover@artimaging.com
Internet: **http://www.dovertechsupport.com**
The fastest way to receive technical support is via email or the Internet.

001

002

003

004

005

006

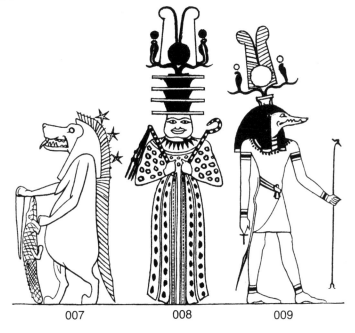

007 008 009

010

007. Taurt. **008.** Osiris the Aged One. **009.** Sebek.

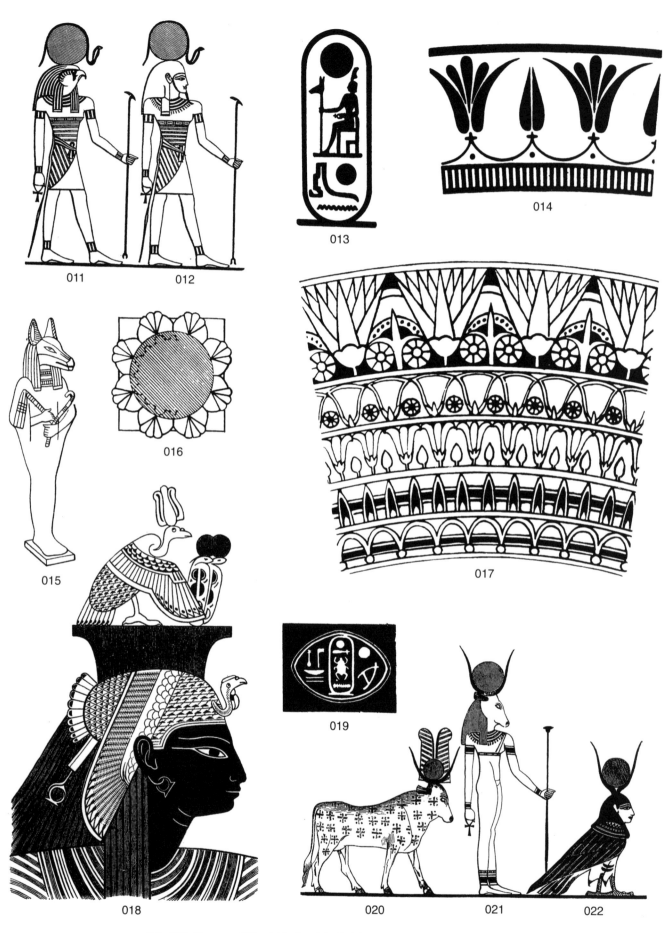

011, 012. Forms of Re. **015.** Anubis-Osiris. **020–022.** Forms of Hathor.

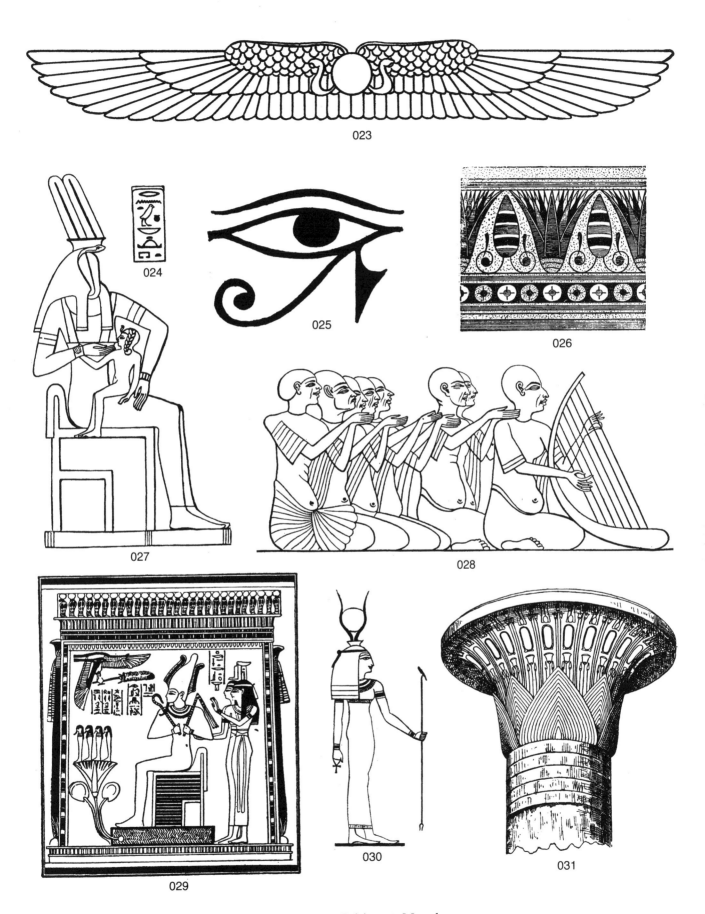

023

024

025

026

027

028

029

030

031

027. Rennut. **029.** Osiris. **030.** Merseber.

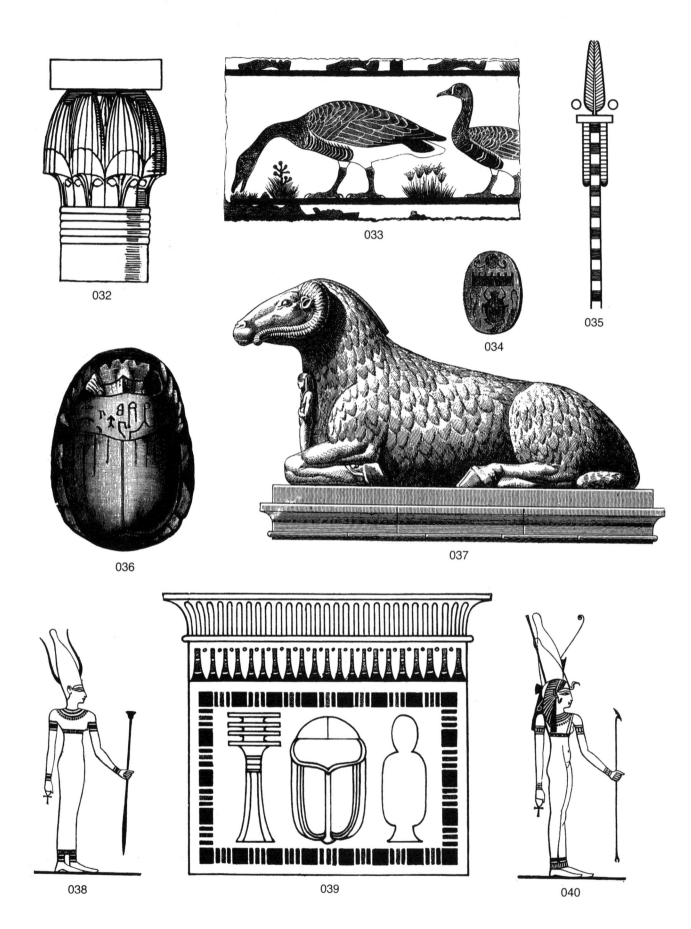

032

033

034

035

036

037

038

039

040

038. Sati. **040.** Mut.

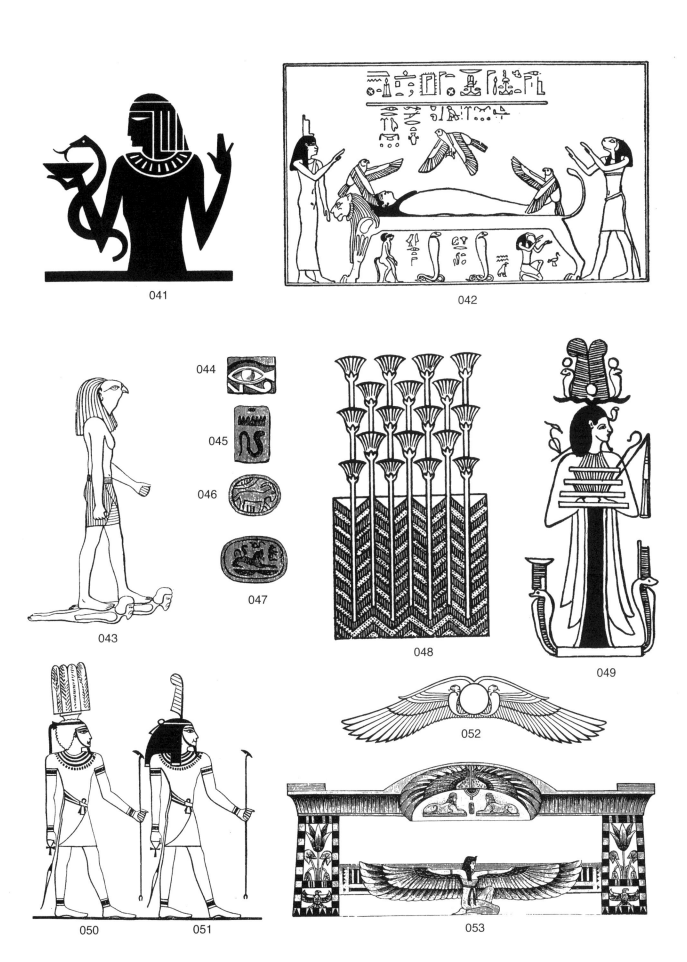

041

042

044

045

046

047

043

048

049

052

050 051

053

043. Re. **049.** Tet with head of Osiris. **050, 051.** Forms of Shu.

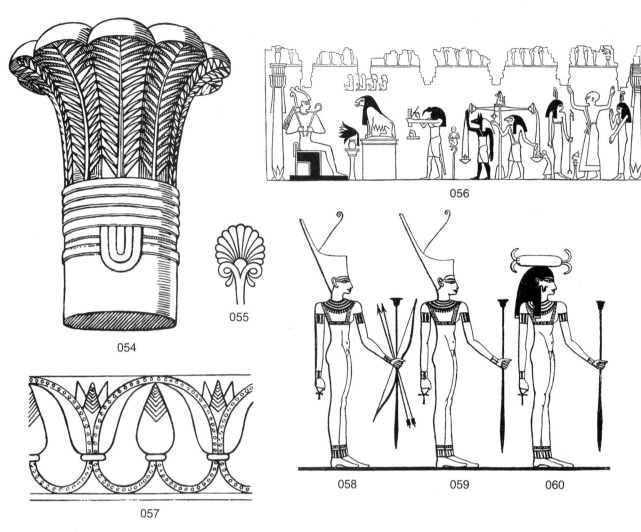

054

055

056

057

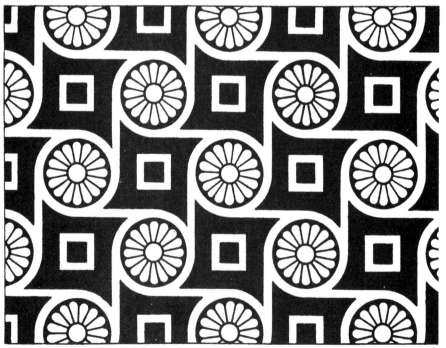

058 059 060

061

062

058–060. Forms of Neith.

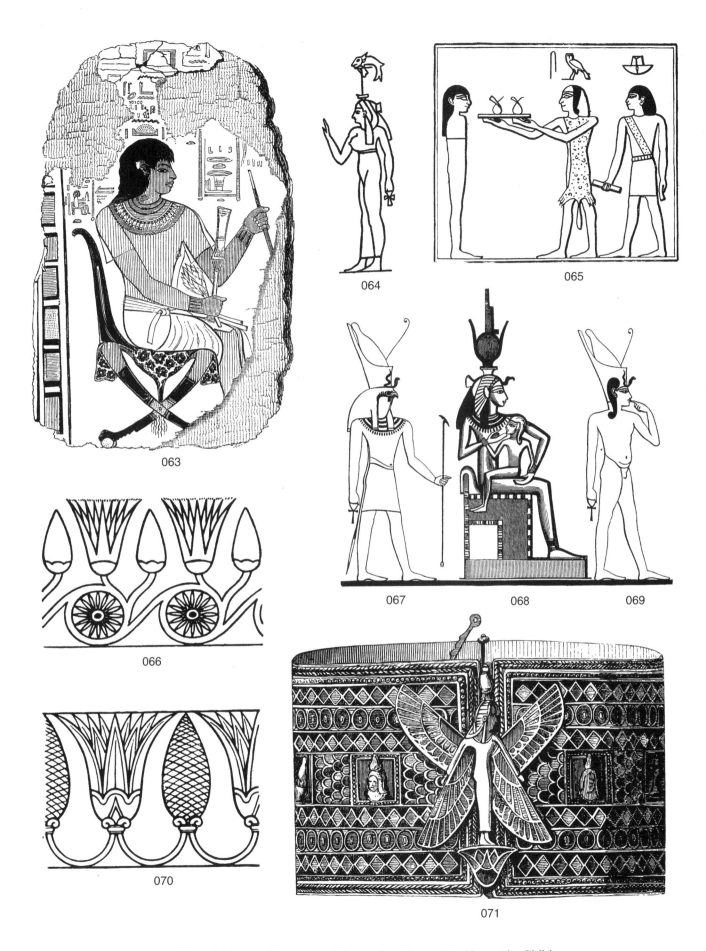

063

064

065

066

067 068 069

070

071

064. Hat-Mehit. **067.** Horus. **068.** Isis nursing Horus. **069.** Horus the Child.

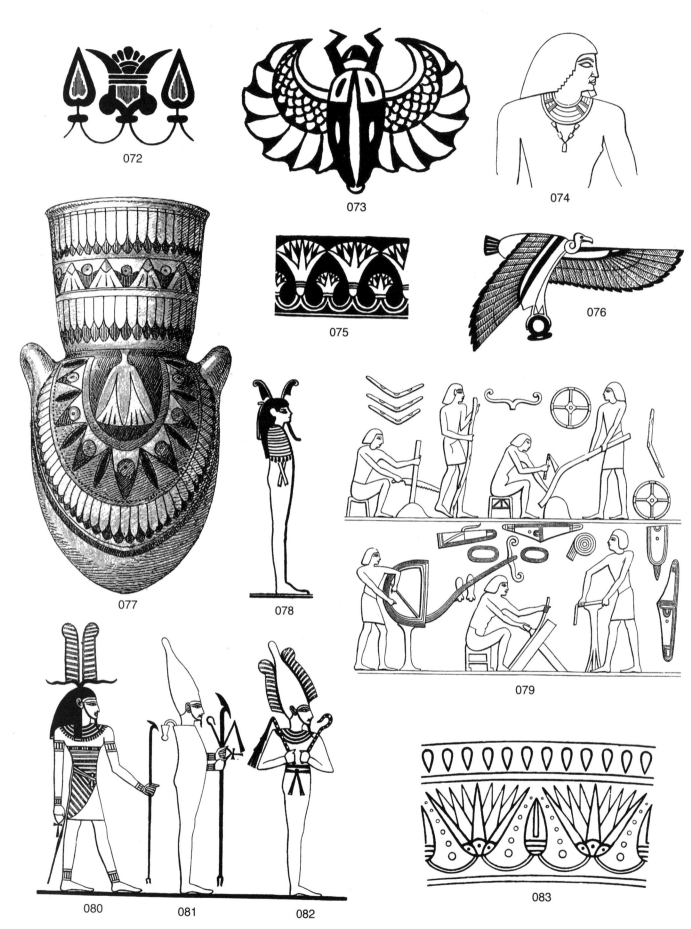

072

073

074

075

076

077

078

079

080 081 082

083

080–082. Forms of Osiris.

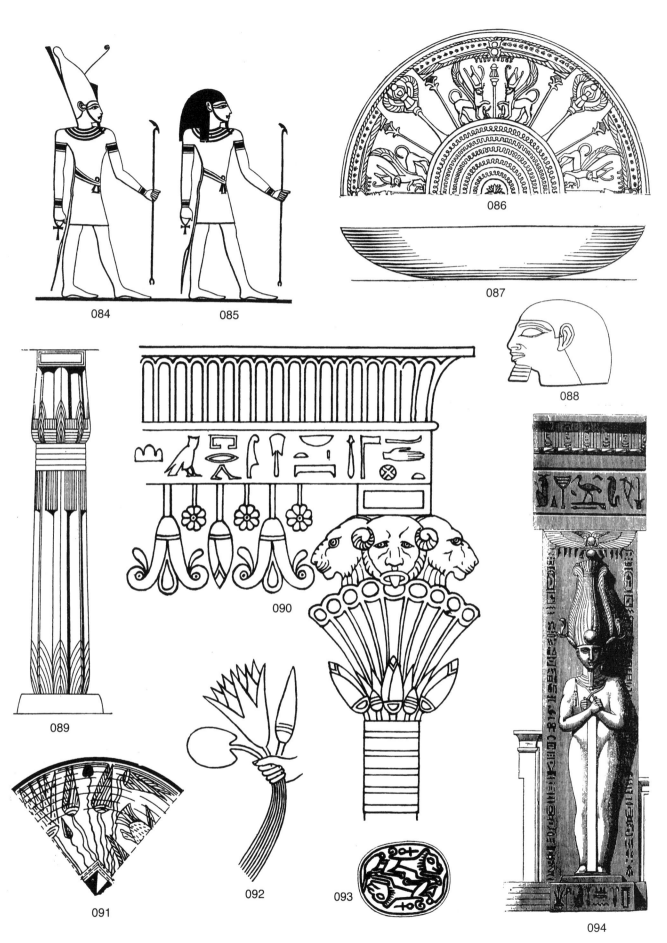

084, 085. Forms of Atum.

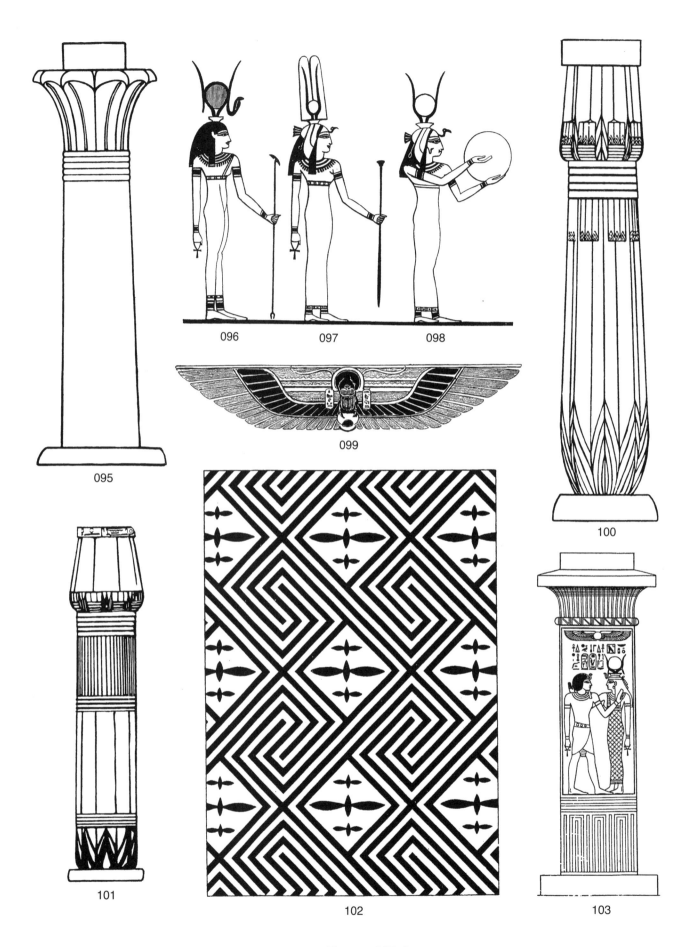

095

096 097 098

099

100

101

102

103

096–098. Forms of Hathor.

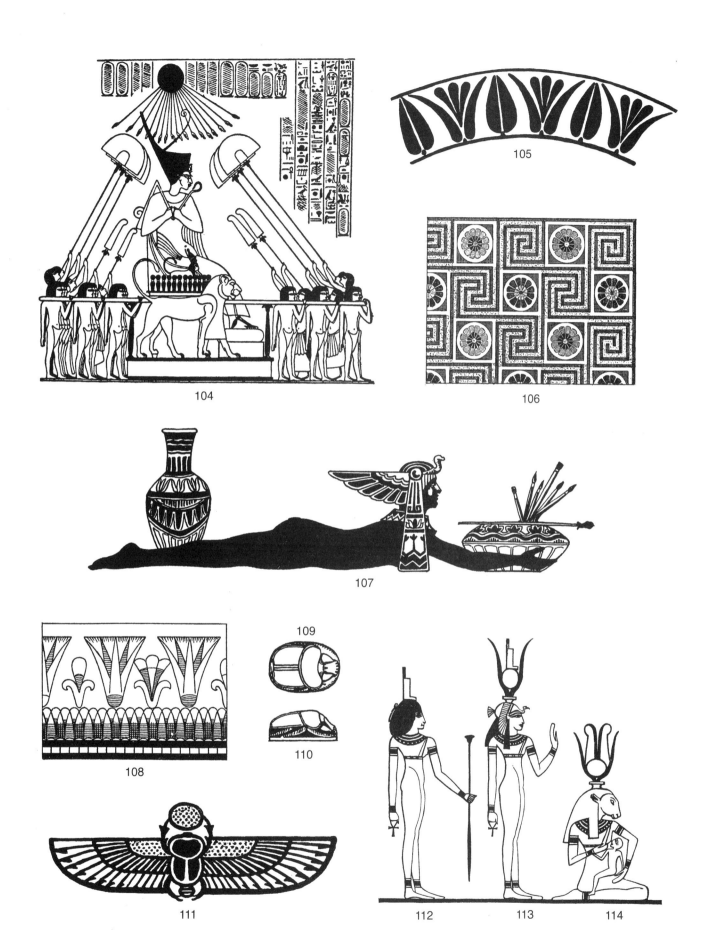

104

105

106

107

108

109

110

111

112 113 114

112–114. Forms of Isis.

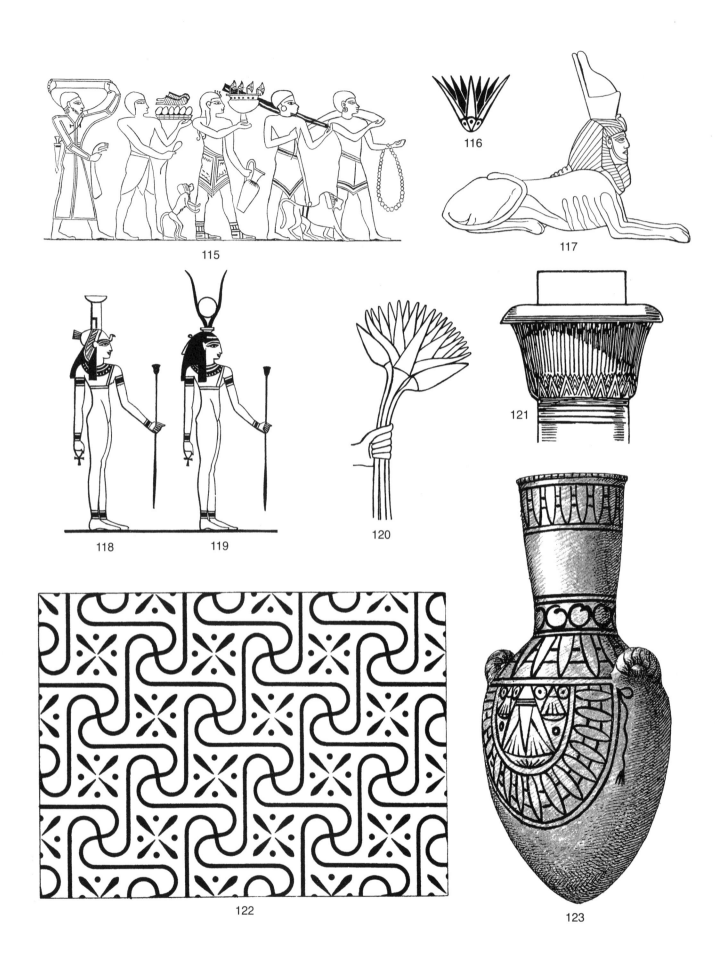

115

116

117

118 119

120

121

122

123

118, 119. Forms of Nephthys.

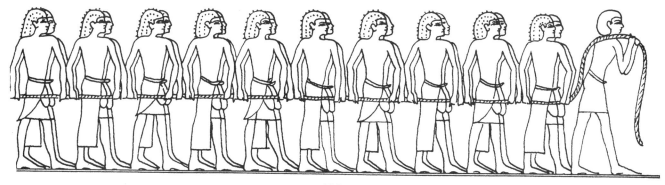

124

125

126

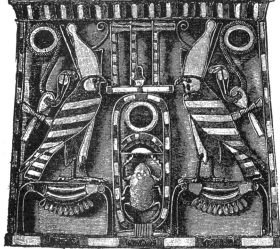

127

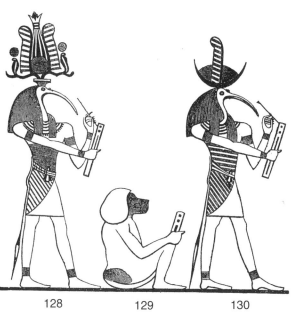

128 129 130 131

128–130. Forms of Thoth.

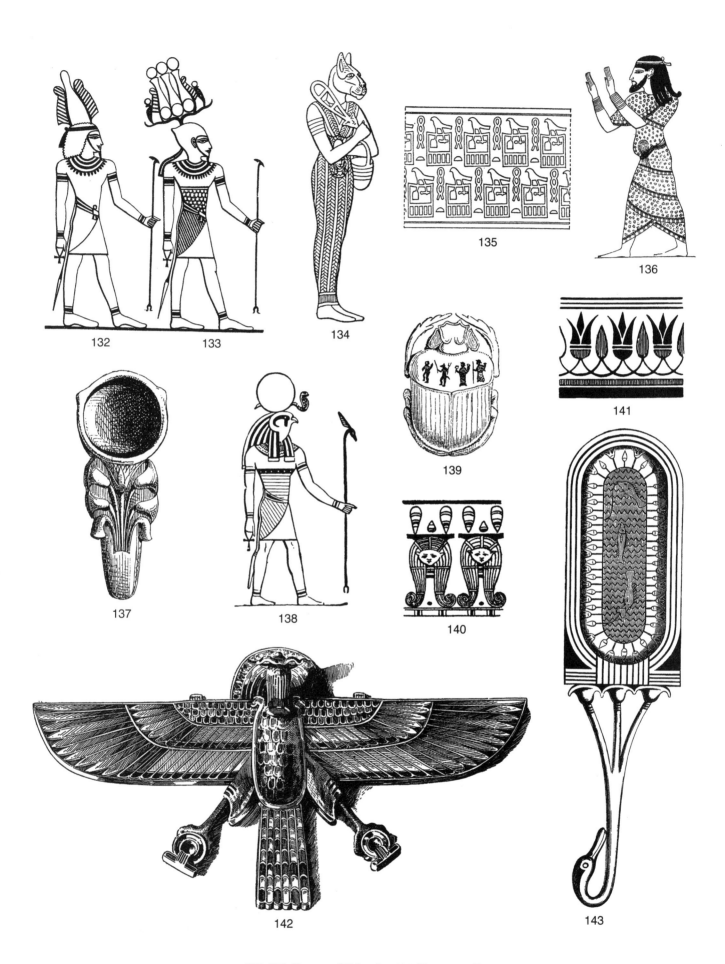

132 133 134 135 136

137 138 139 140 141

142 143

132, 133. Forms of Merula. **134.** Bast. **138.** Re.

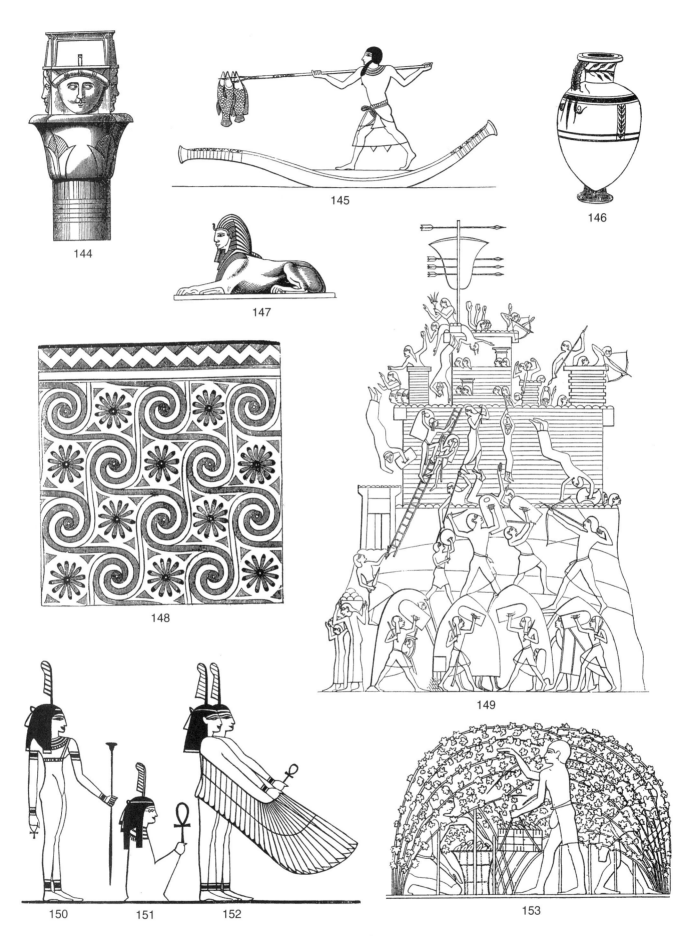

144

145

146

147

148

149

150 151 152 153

150–152. Forms of Ma.

154

155

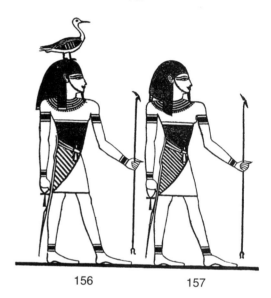

156 157

158

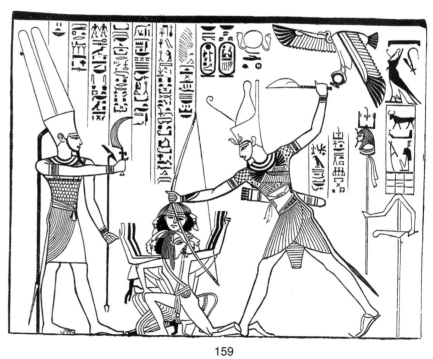

159

156, 157. Forms of Geb.

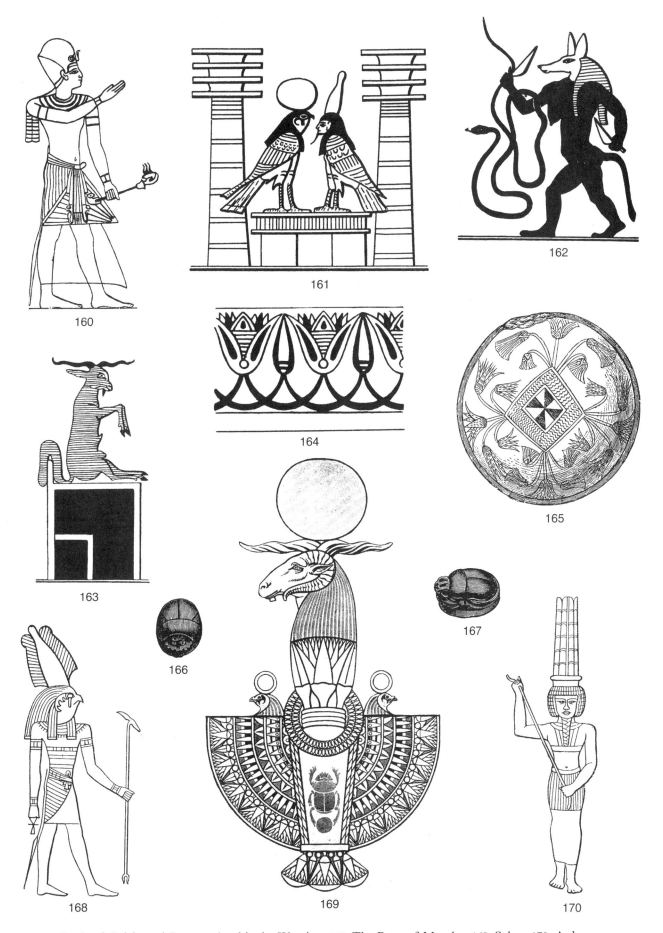

160

161

162

163

164

165

166

167

168

169

170

161. Souls of Osiris and Re. **162.** Anubis the Warrior. **163.** The Ram of Mendes. **168.** Seker. **170.** Anher.

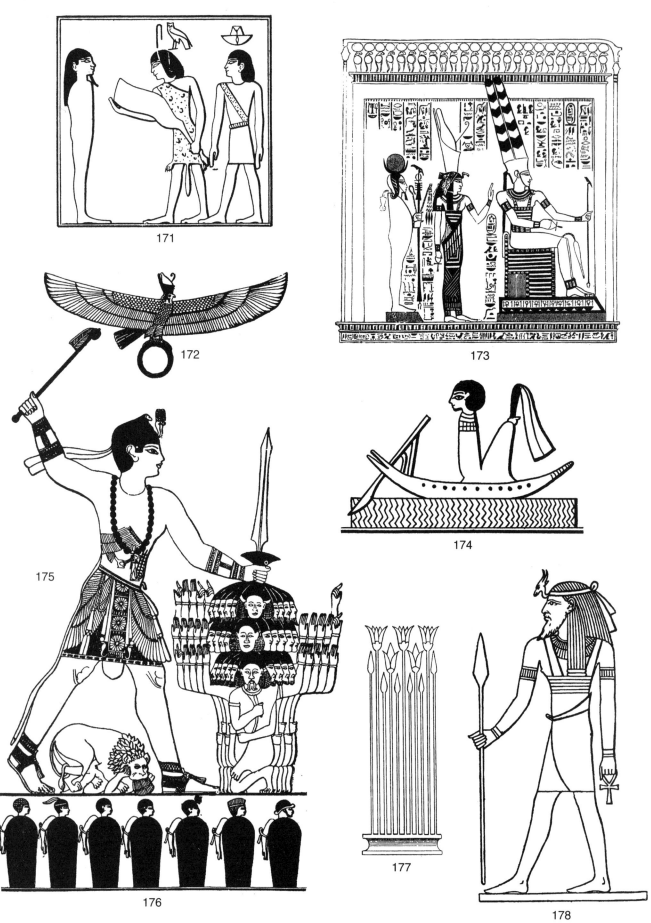

171

172

173

174

175

176

177

178

174. Her-f Ha-f. **178.** Reshpu.

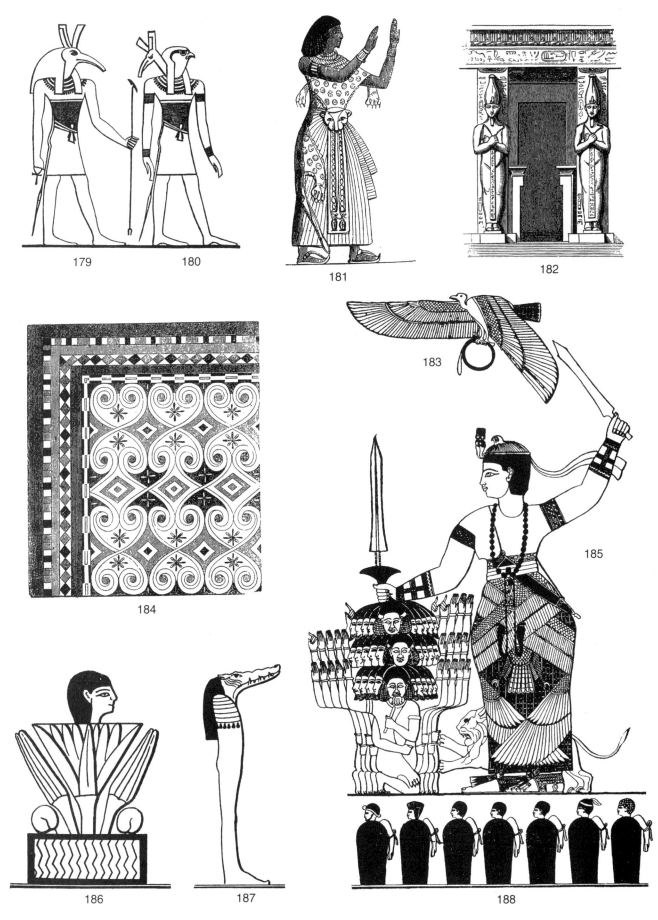

179, 180. Forms of Seth. **186.** Re. **187.** Sebek.

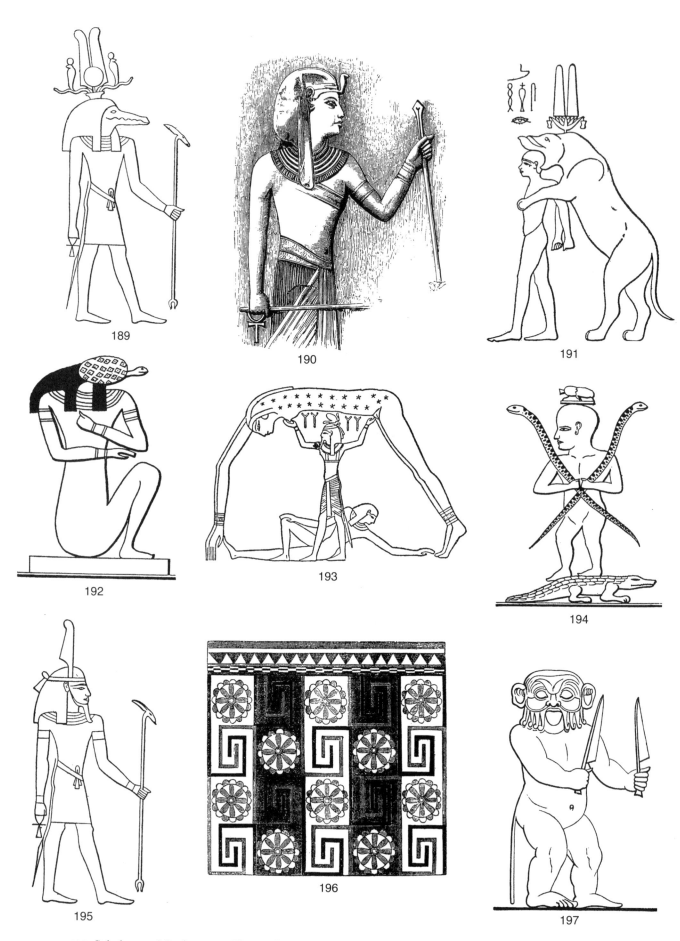

189. Sebek. 191. Maahes. 192. The turtle god. 193. Nut raised up by Shu. 194. Ptah. 195. Shu. 197. Bes.

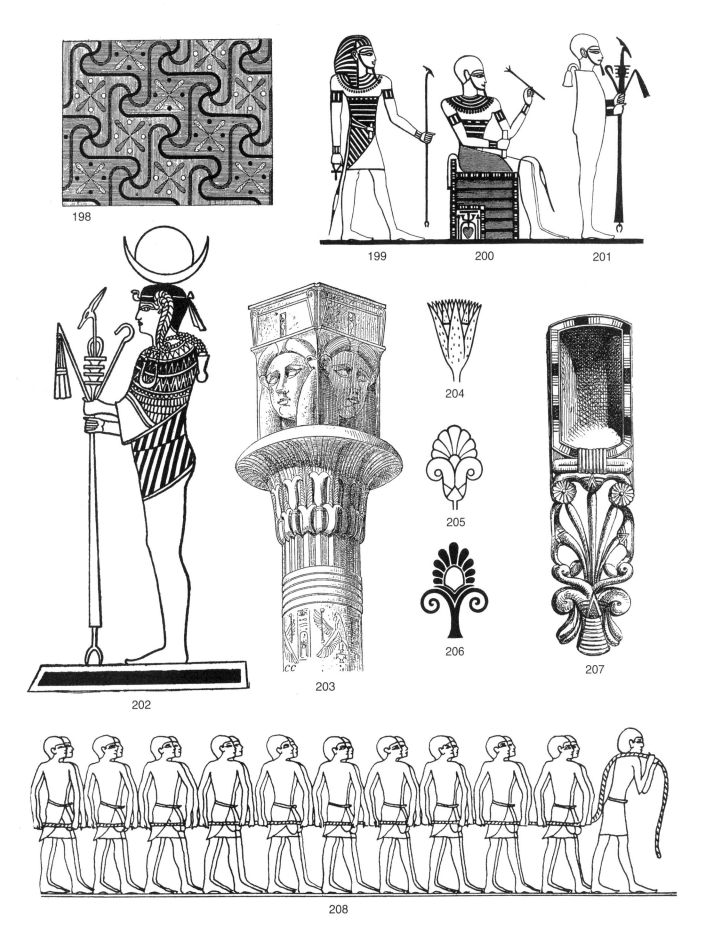

198

199 200 201

202 203 204

205

206

207

208

199–201. Forms of Ptah. **202.** Osiris.

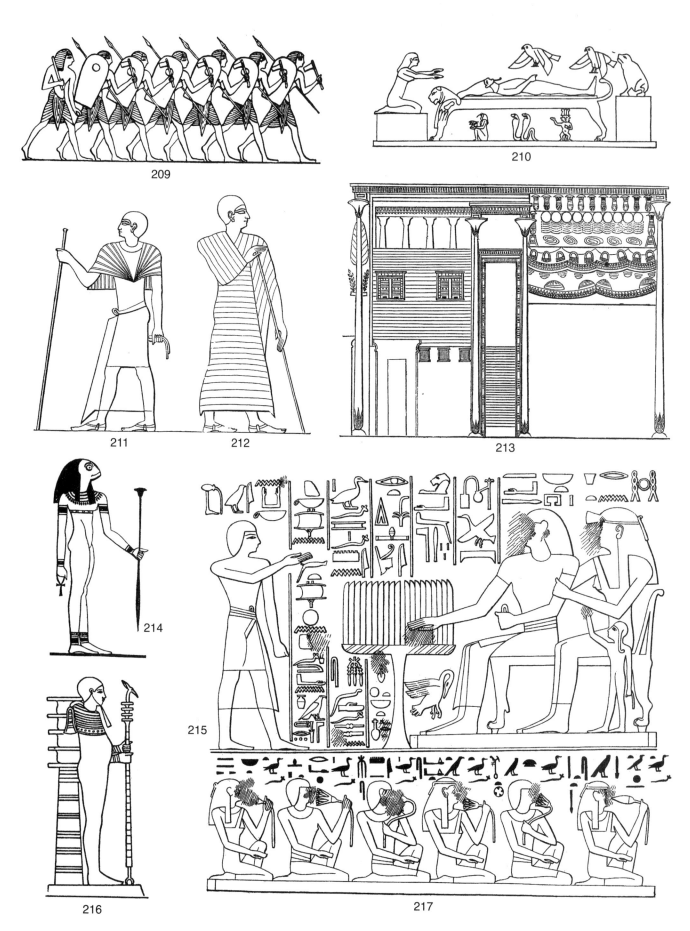

214. Hak. **216.** Ptah.

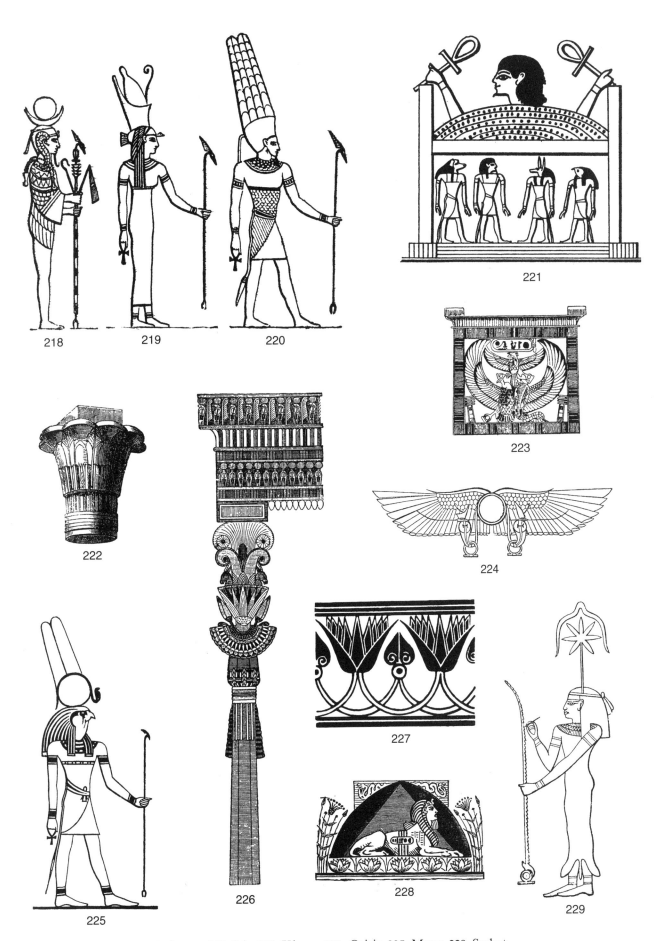

218. Amon. **219.** Isis. **220.** Khons. **221.** Osiris. **225.** Mons. **229.** Seshat.

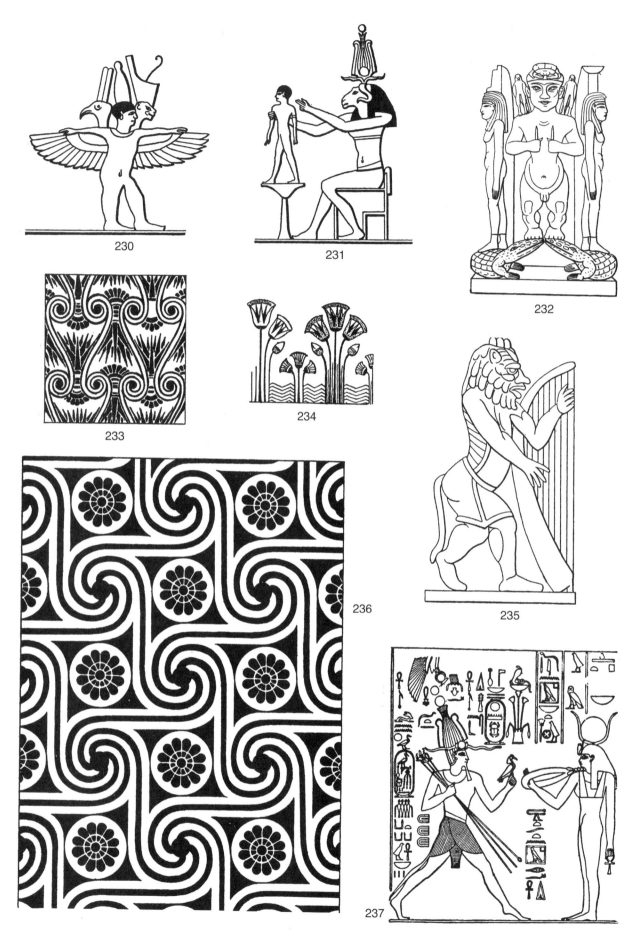

230. Sekhmet-Bst-Re. 231. Khnum. 232. Ptah. 235. Bes.

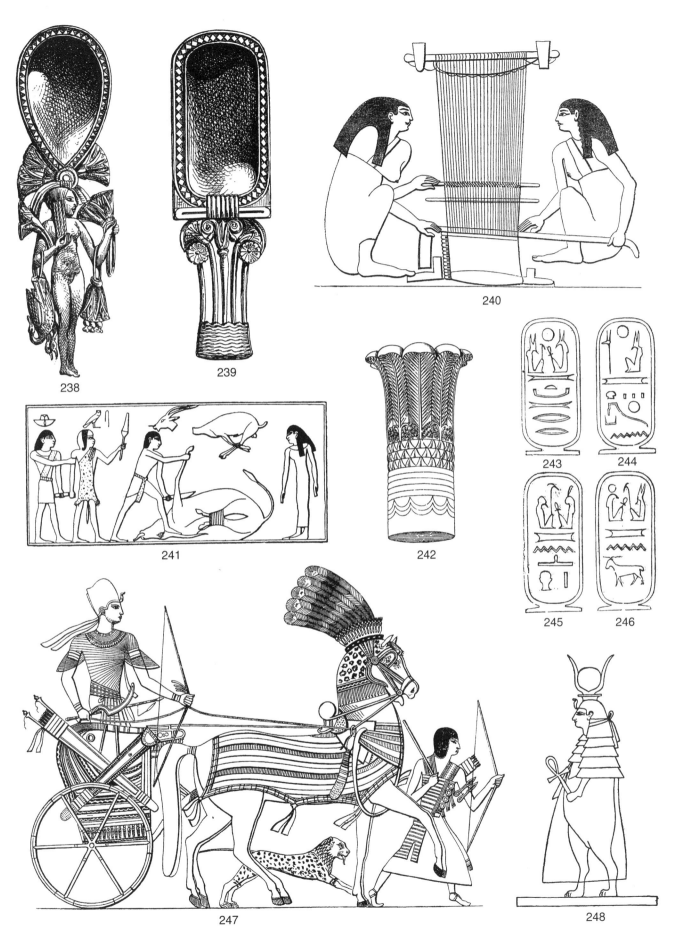

238 239 240 241 242 243 244 245 246 247 248

248. Taurt.

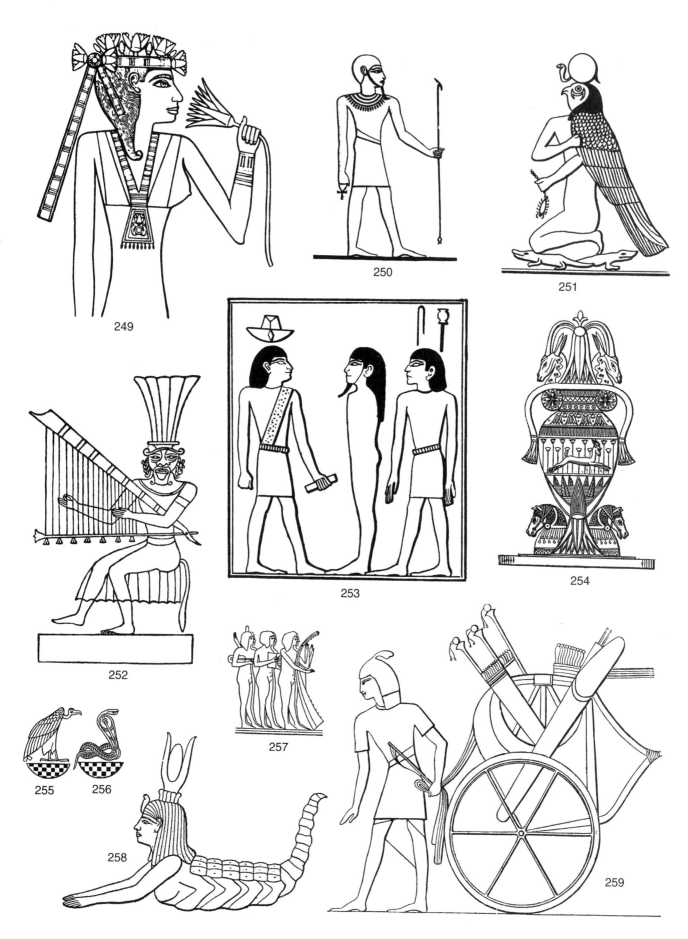

249

250

251

252

253

254

255 256

257

258

259

250. Aemhetp. **251.** Sept. **252.** Bes. **258.** Serk-t.

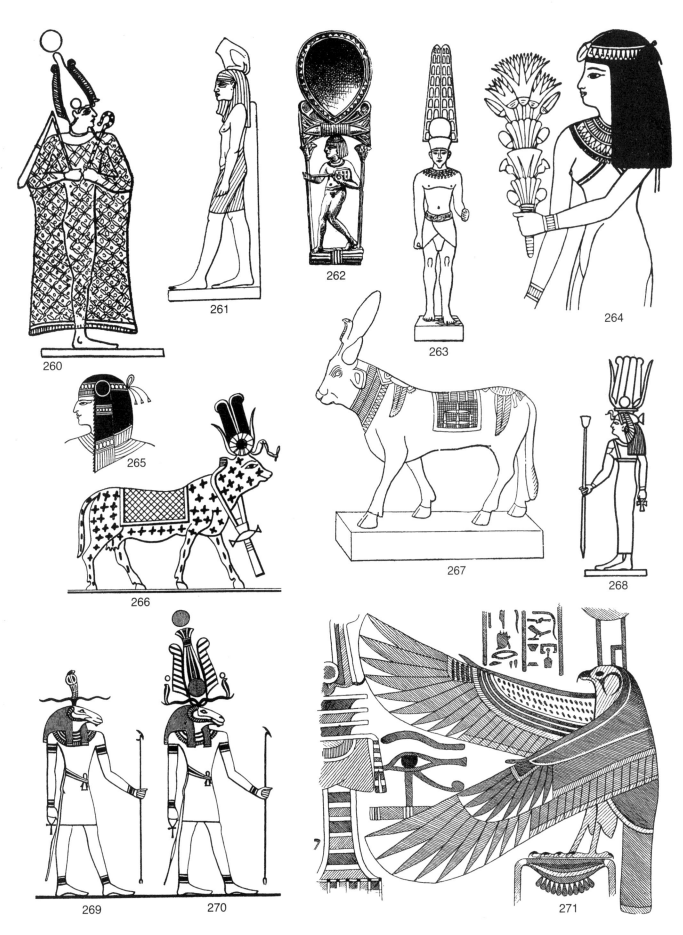

260. Osiris Un-Nefer. 261. Shu. 263. Amon-Re. 266. Hathor as the heaven cow.
267. Apis. 268. Isis. 269, 270. Forms of Kneph.

31

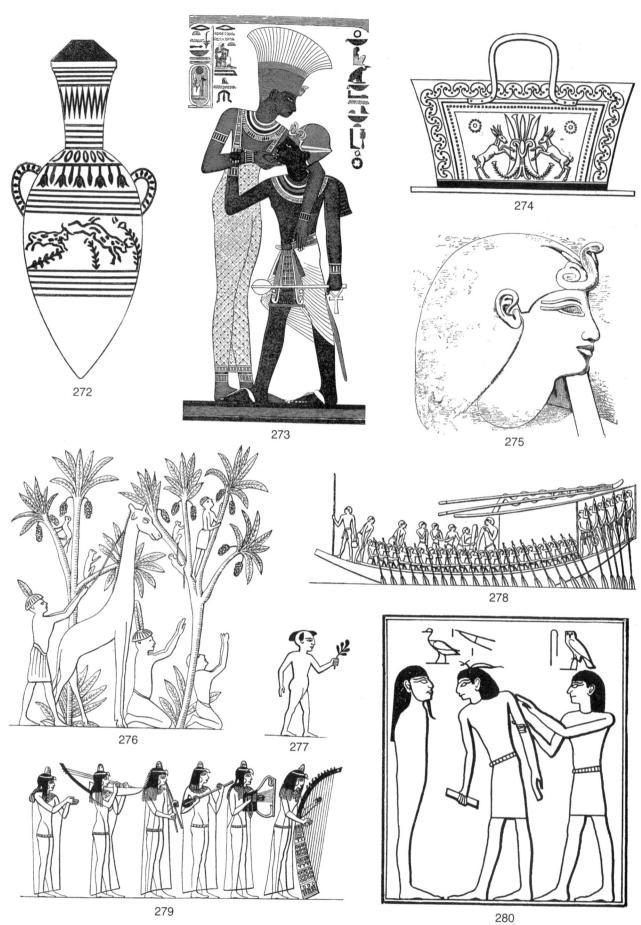

272

273

274

275

276

277

278

279

280

273. Hathor with Ramses II.

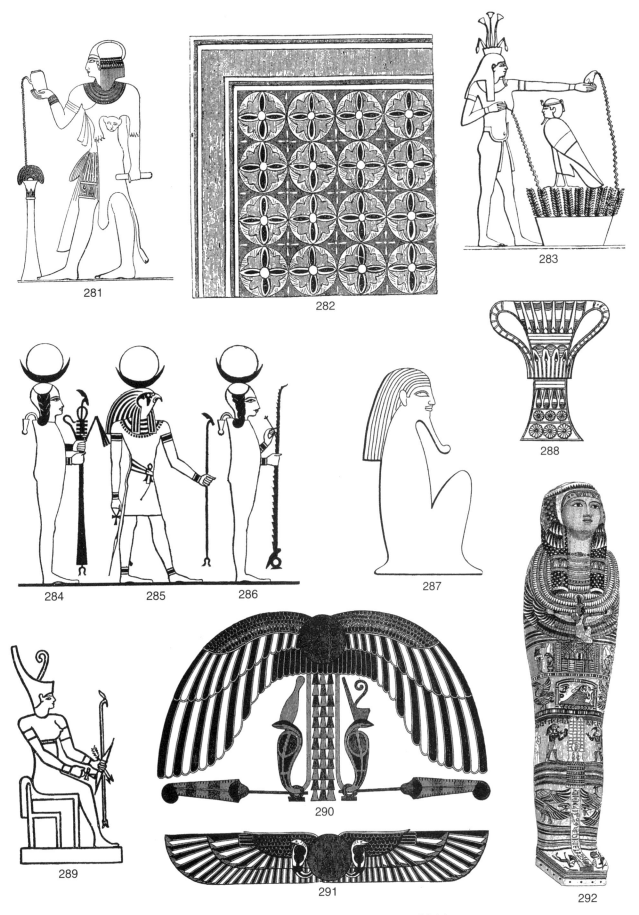

283. Hapi. **284–286.** Forms of Khons. **289.** Neith.

33

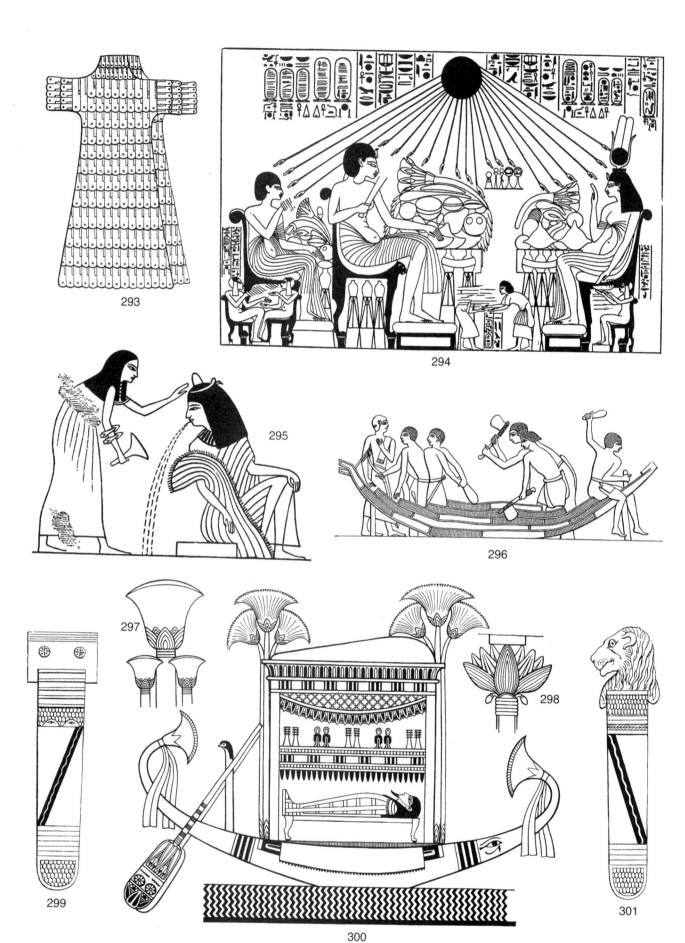

293

294

295

296

297

298

299

300

301

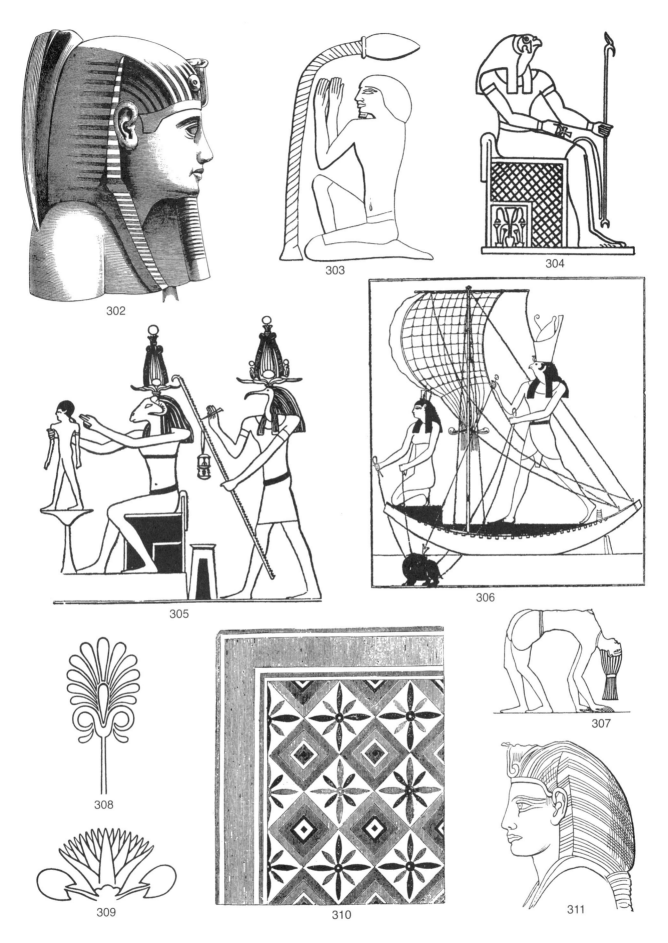

304. Seker. **305.** Khnum and Thoth. **306.** Isis and Horus.

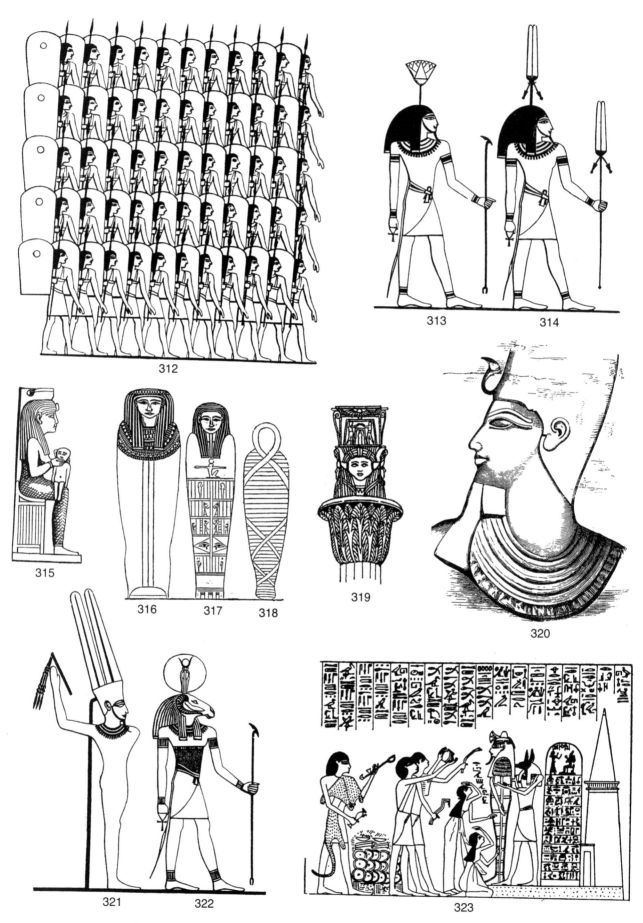

313, 314. Forms of Nefertum. **315.** Isis and Horus. **321.** Amon-Khem. **322.** Amon-Kneph.

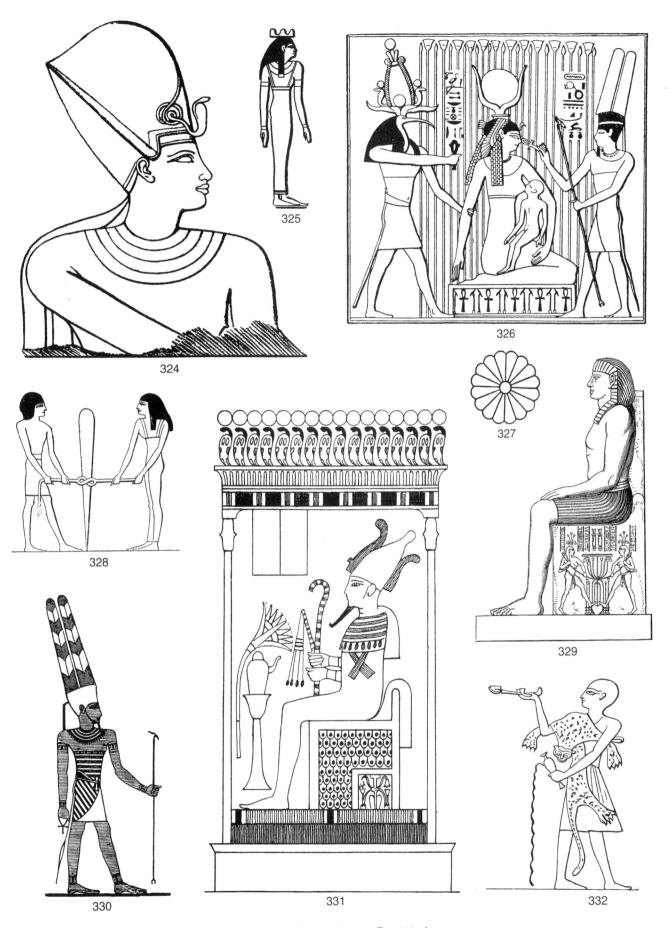

326. Thoth, Isis, Horus, Amon-Re. **330.** Amon.

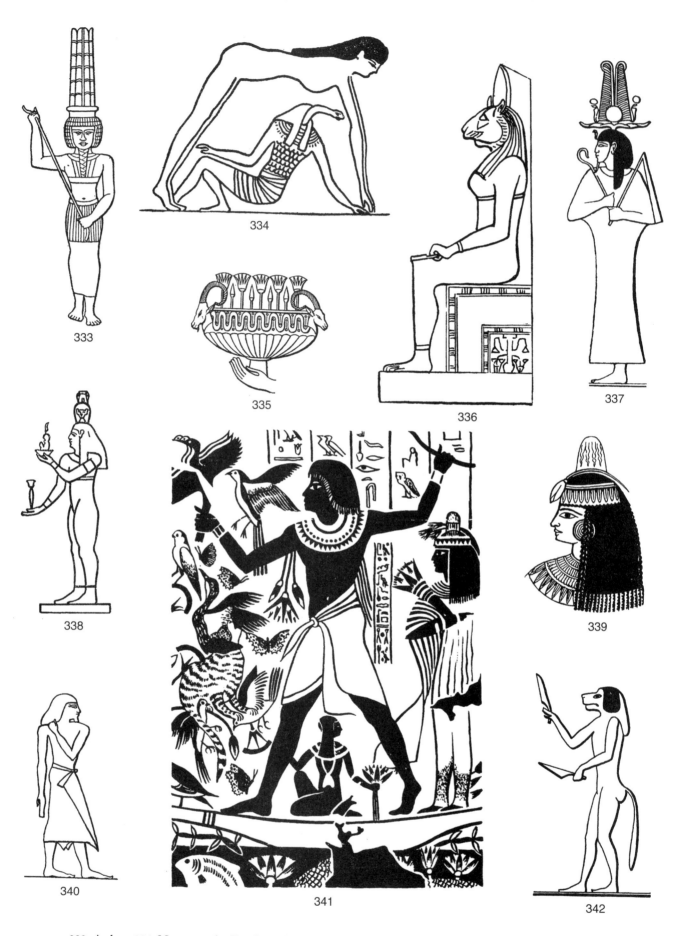

333. Anher. **334.** Nut over the Earth-god. **336.** Bast. **337.** Osiris. **338.** Nehemauit. **342.** The Dog-god.

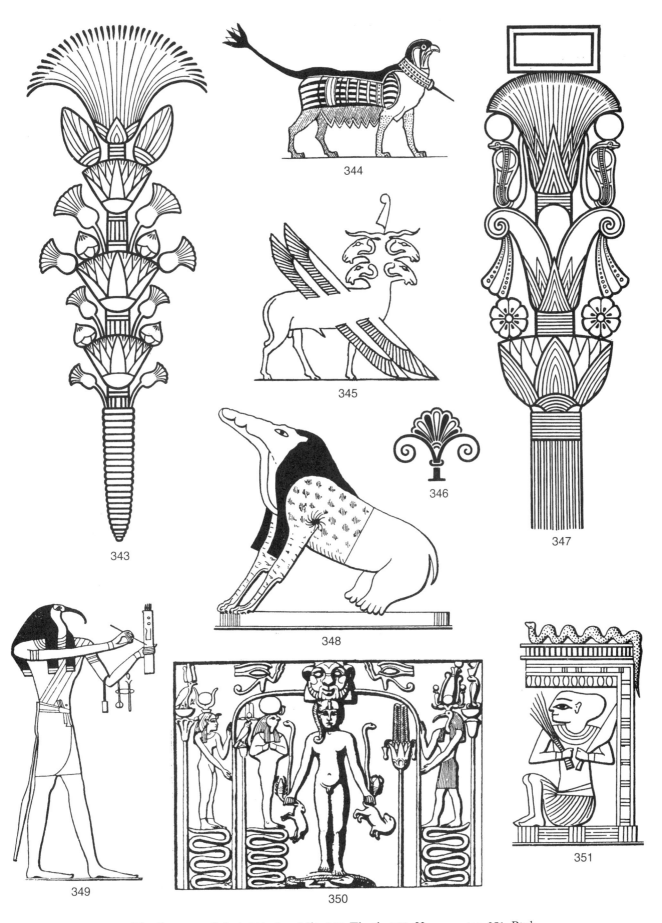

344. The Sag. **345.** Qebui. **348.** Am-Mit. **349.** Thoth. **350.** Harpocrates. **351.** Ptah.

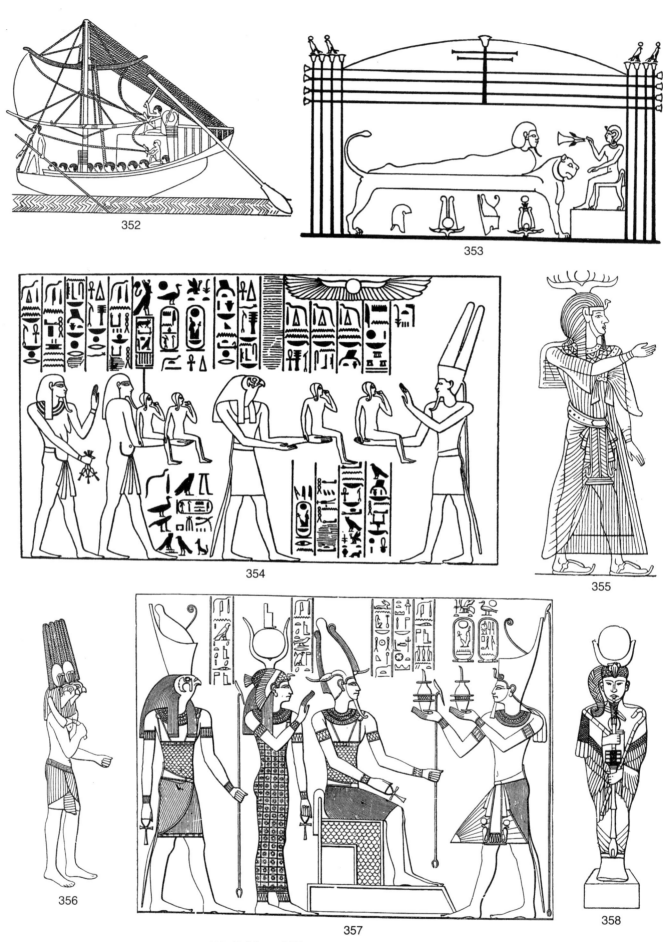

352

353

354

355

356

357

358

353. Osiris and Horus. **356.** Amon-Re. **358.** Khons.

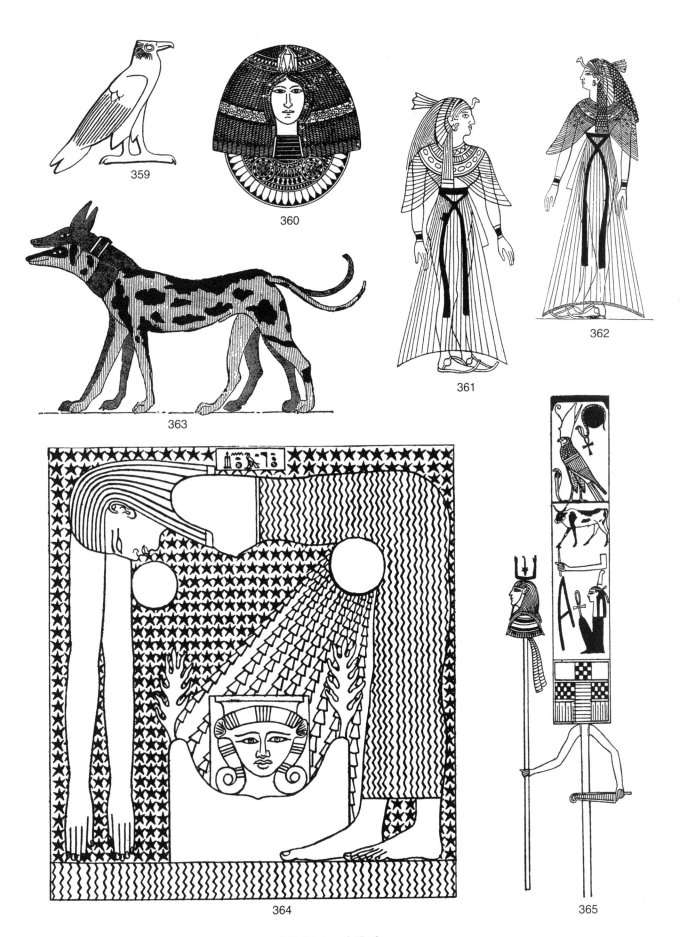

364. Nut and Hathor.

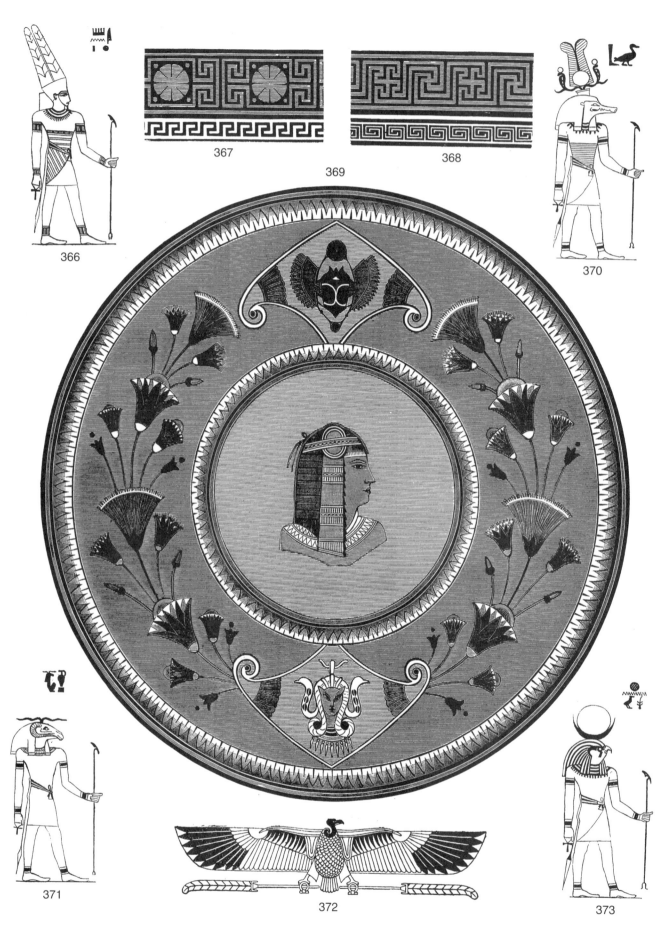

366 367 369 368 370

366 371 372 373

366. Amon-Re. **370.** Sebek. **371.** Kneph. **373.** Khons.

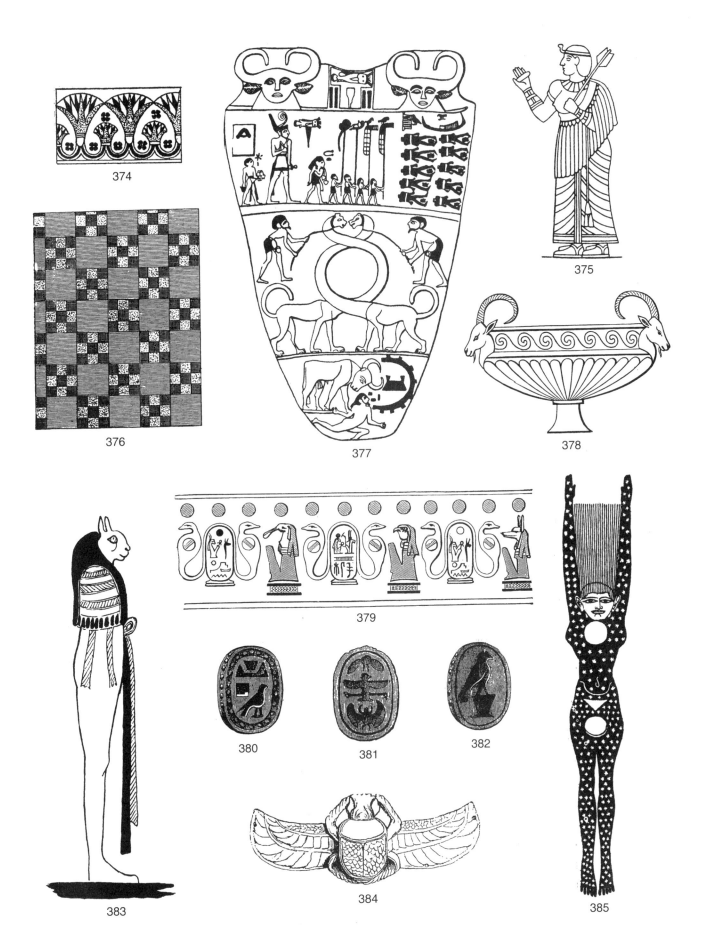

374

376

377

375

378

379

380

381

382

383

384

385

385. Nut.

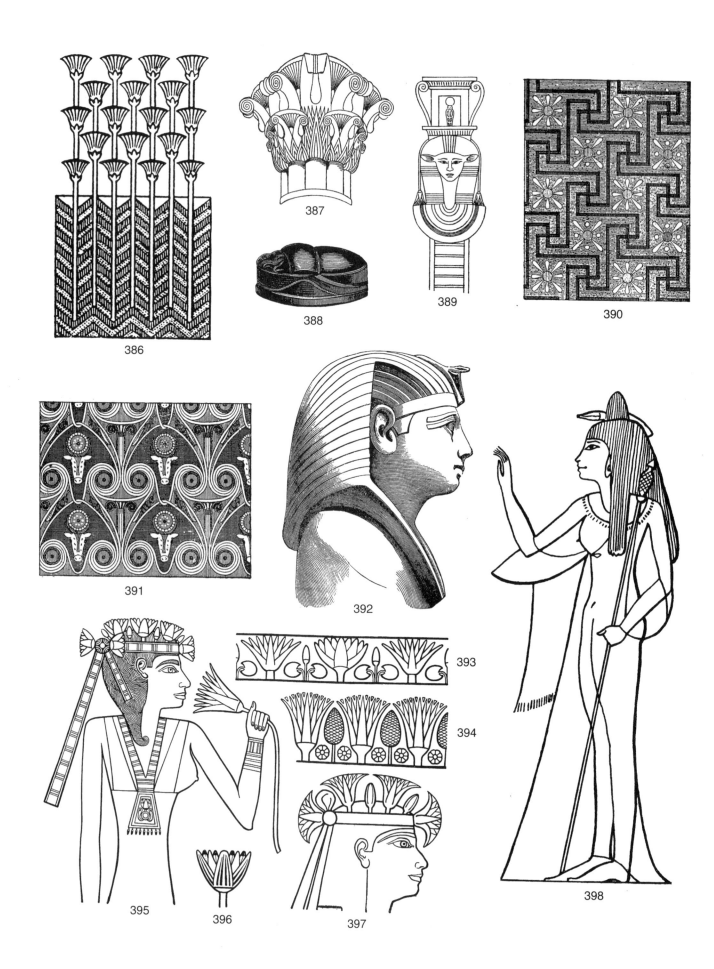

386

387

388

389

390

391

392

393

394

395

396

397

398

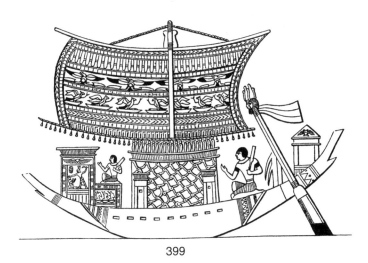

399

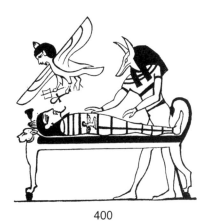

400

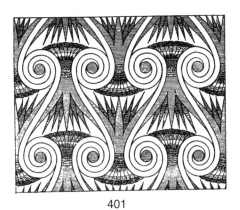

401

402

403

404

405

406

407

408

409

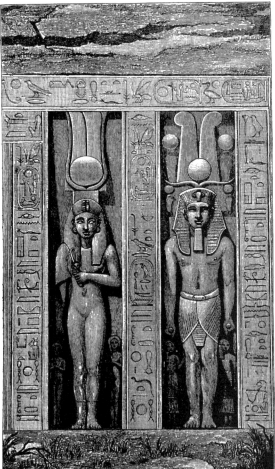

410

400. Anubis.

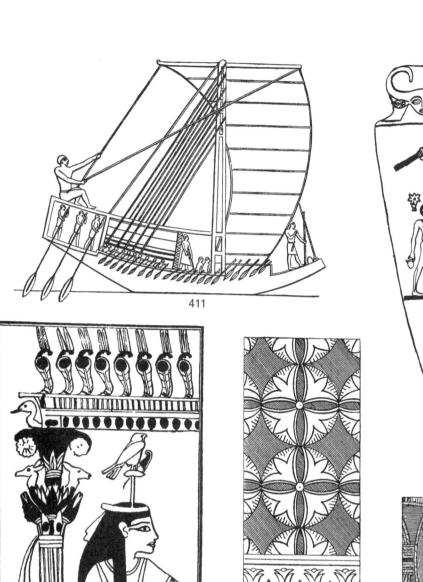

411

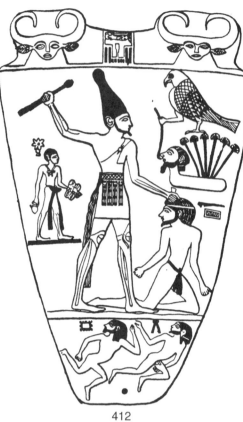

412

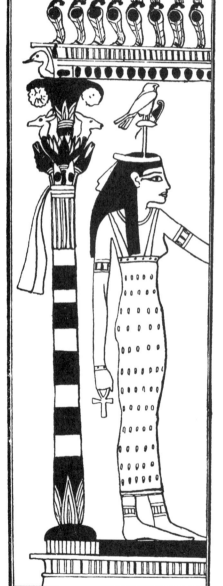

415

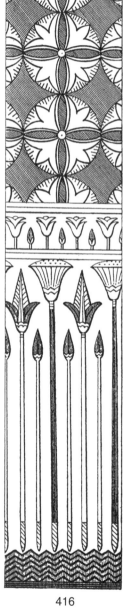

416

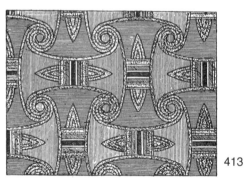

413

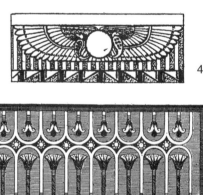

414

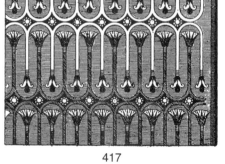

417

415. Amentat.

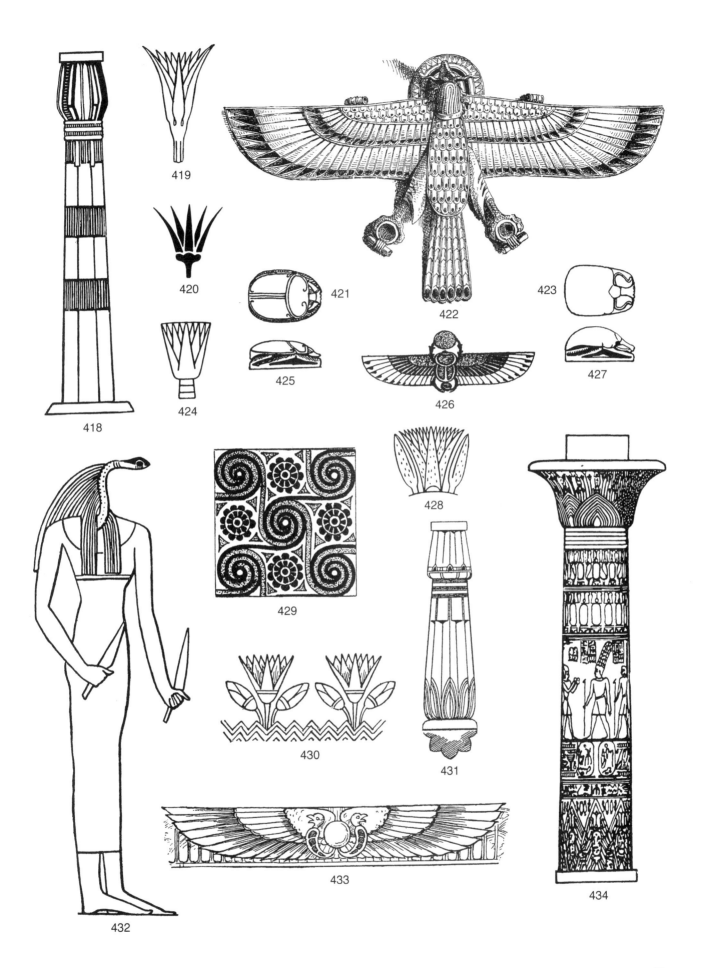

418

419

420

421

422

423

424

425

426

427

428

429

430

431

432

433

434

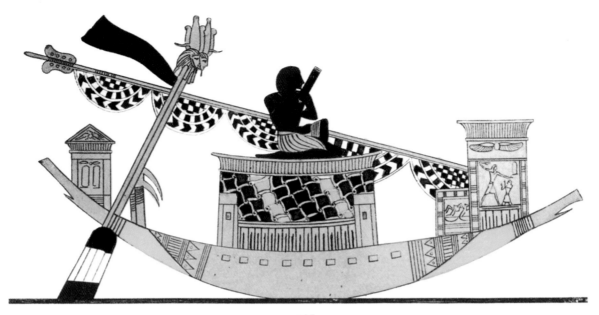

435

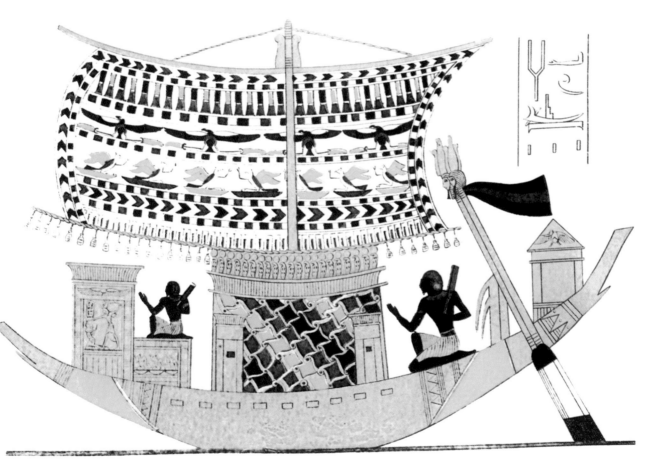

436

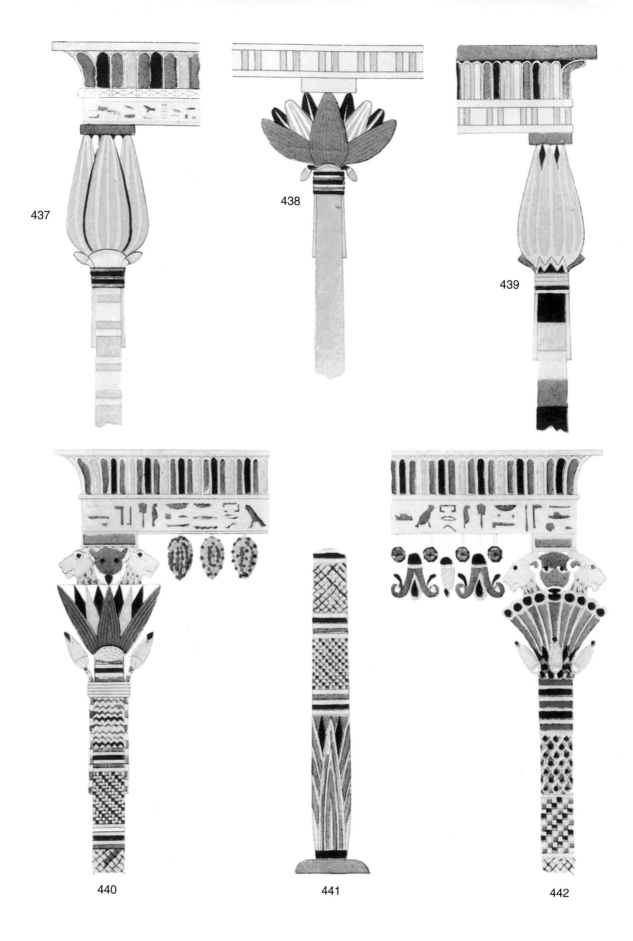

437

438

439

440

441

442

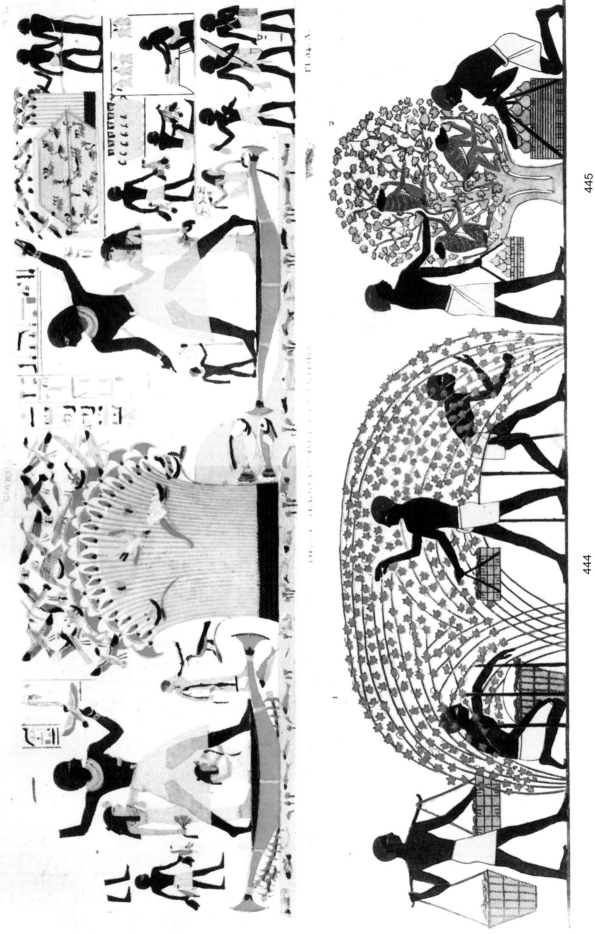

443

444

445

51

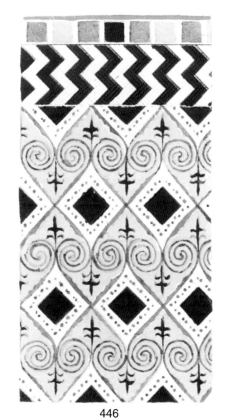

446

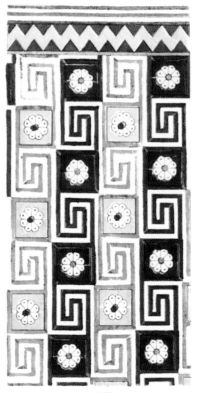

447

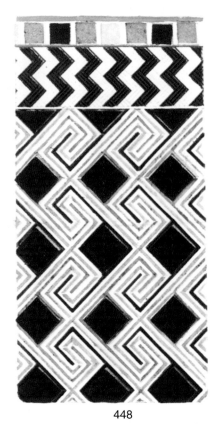

448

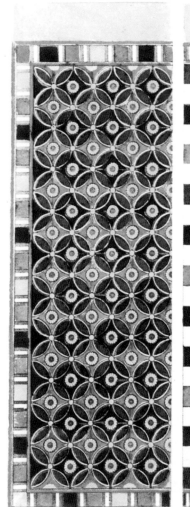

449

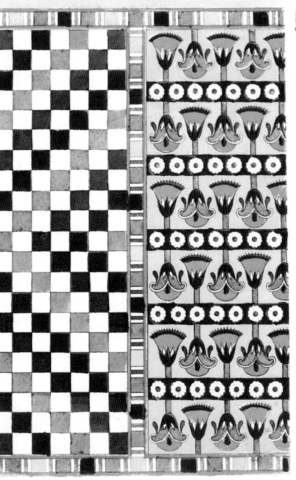

450

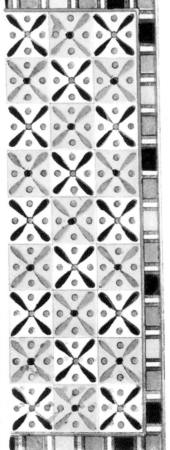

451

52